Elegant Designs ot the Ages
COLORING BOOK

MOIRA ALLEN

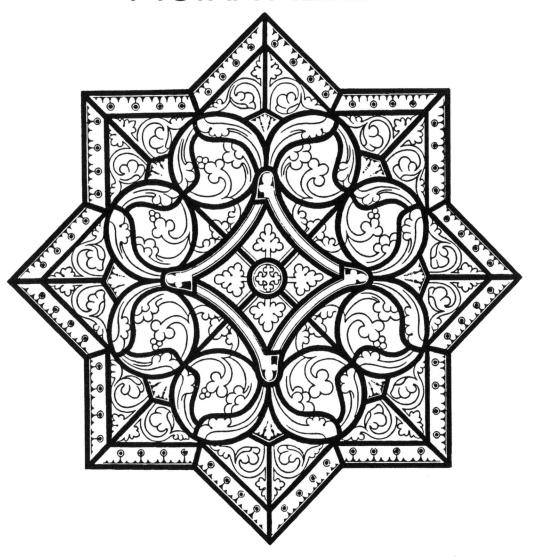

DOVER PUBLICATIONS, INC.
MINEOLA, NEW YORK

Journey the world over and you'll discover that elegant designs exist everywhere, no matter the location or time period. This new coloring book includes sophisticated mosaics, tiles, and stained glass designs that draw inspiration from medieval churches, Roman villas, Asian fabrics, and more. The balanced mix of cultures, tastes, and themes will provide you with hours of enjoyment! Be sure to experiment with color combinations and technique as you work through the illustrations. Each of the thirty-one plates has been perforated for removal to make displaying your work easy.

Bibliographical Note
Elegant Designs of the Ages Coloring Book is a new work,
first published by Dover Publications, Inc., in 2017.

International Standard Book Number
ISBN-13: 978-0-486-81409-4
ISBN-10: 0-486-81409-2

Manufactured in the United States by LSC Communications
81409201 2017
www.doverpublications.com

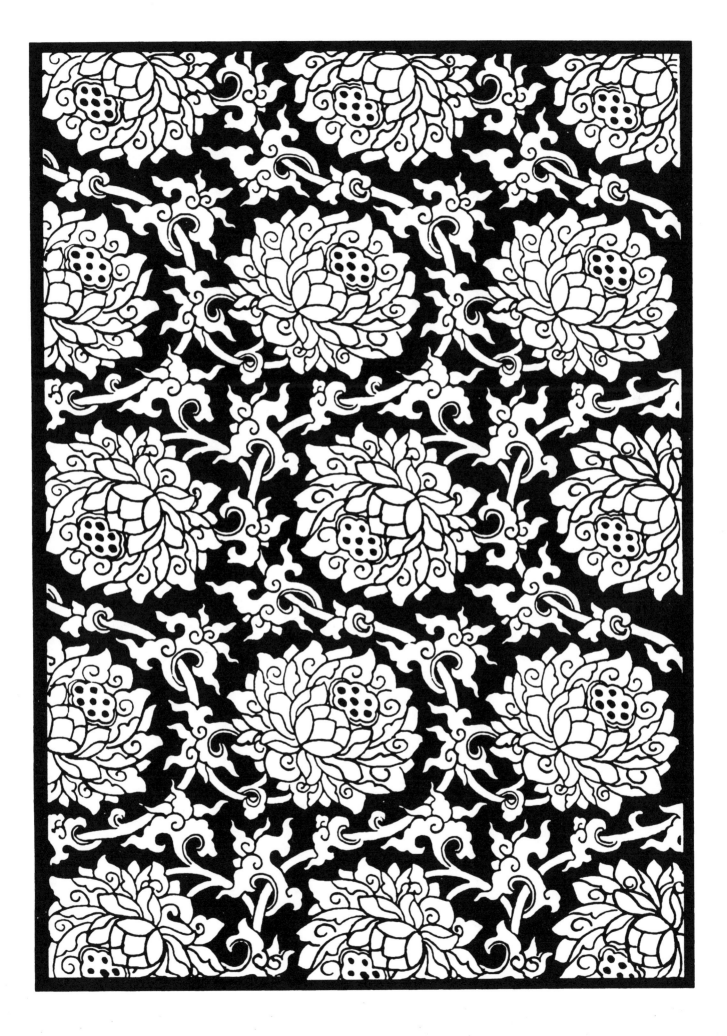

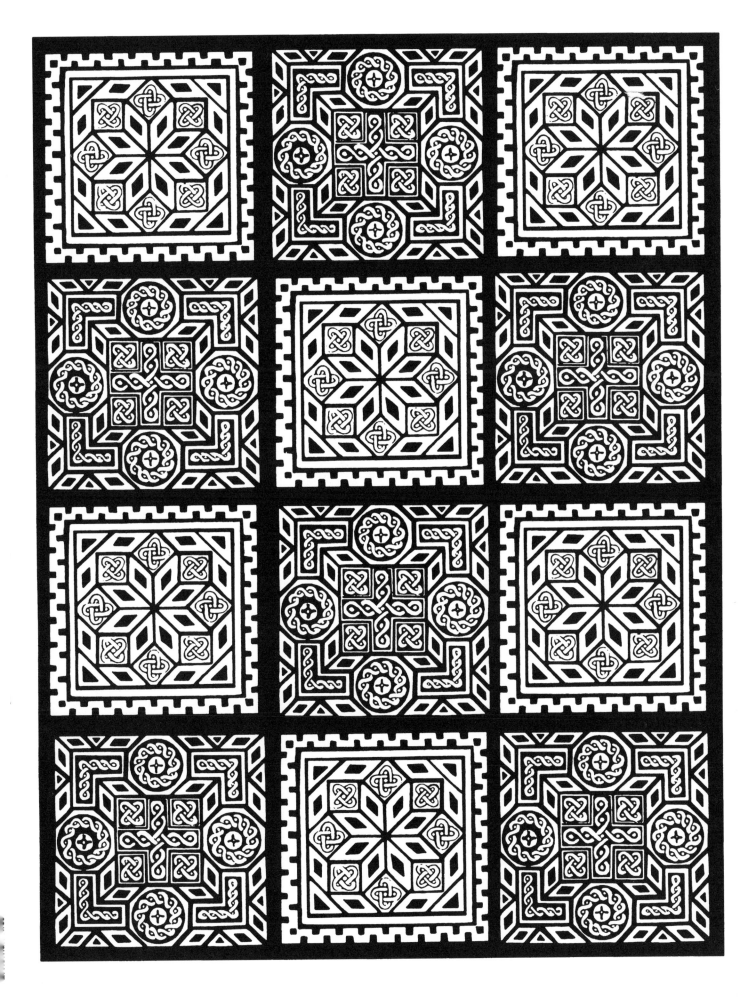

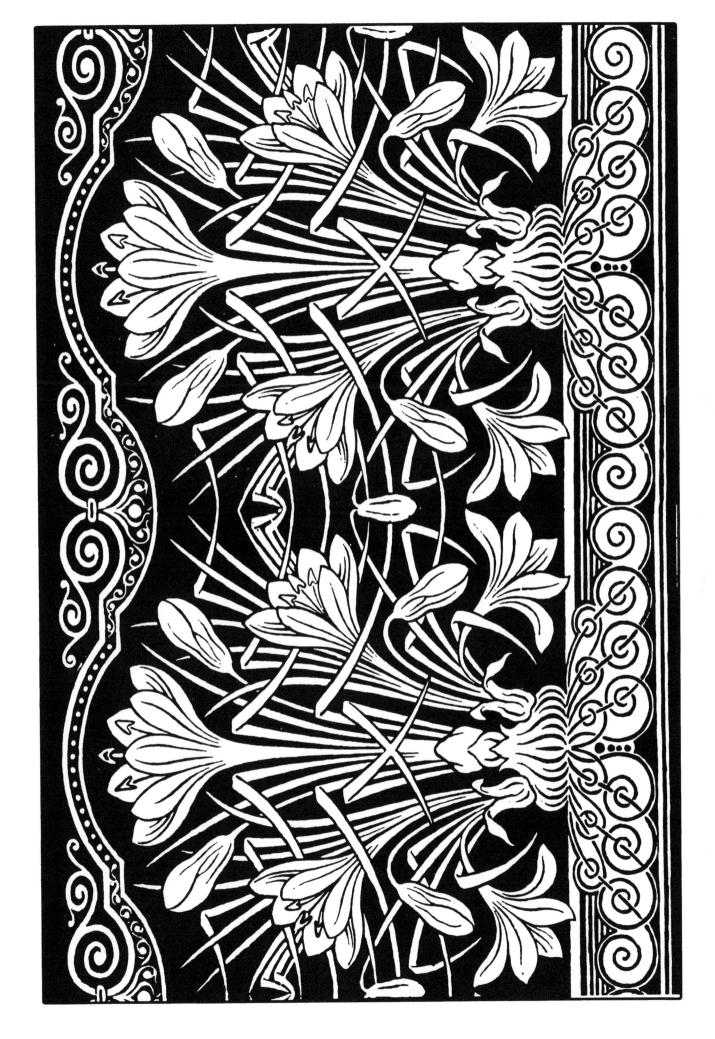

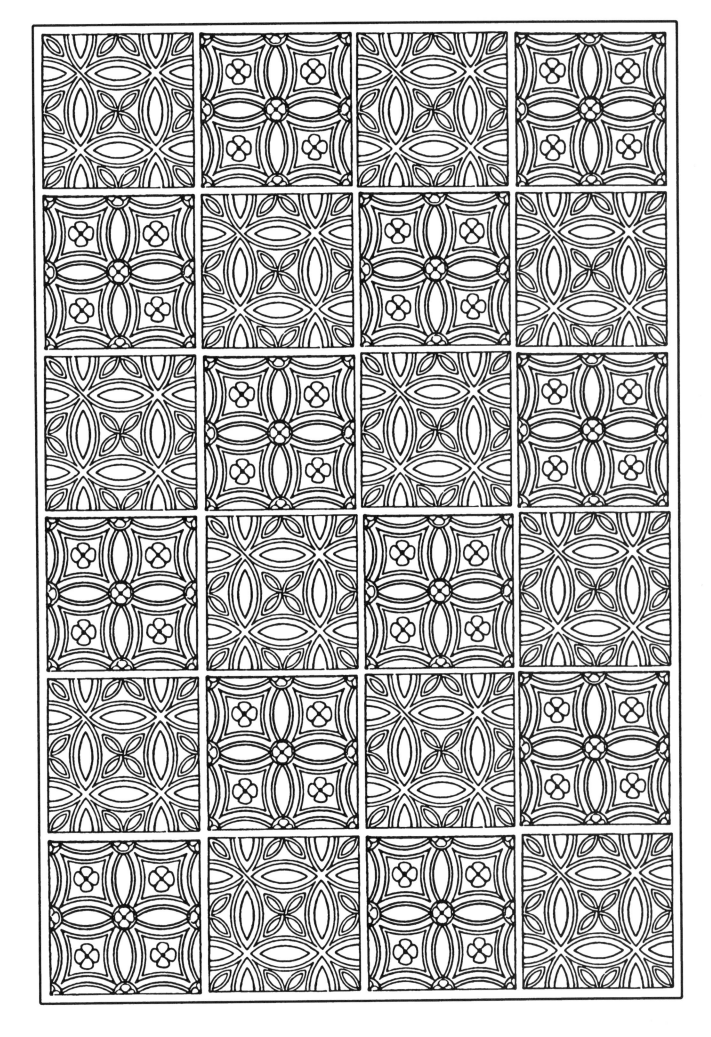

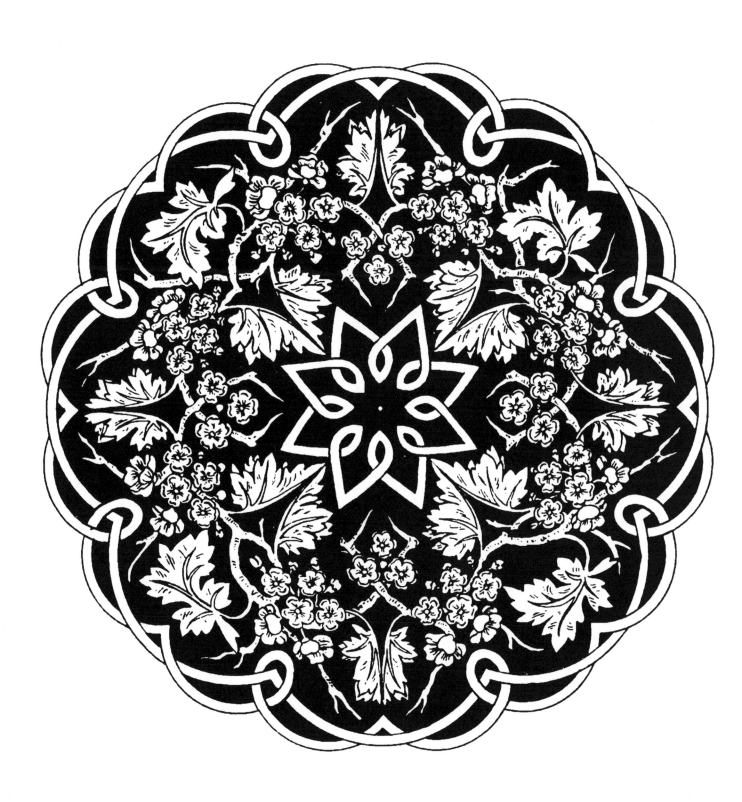

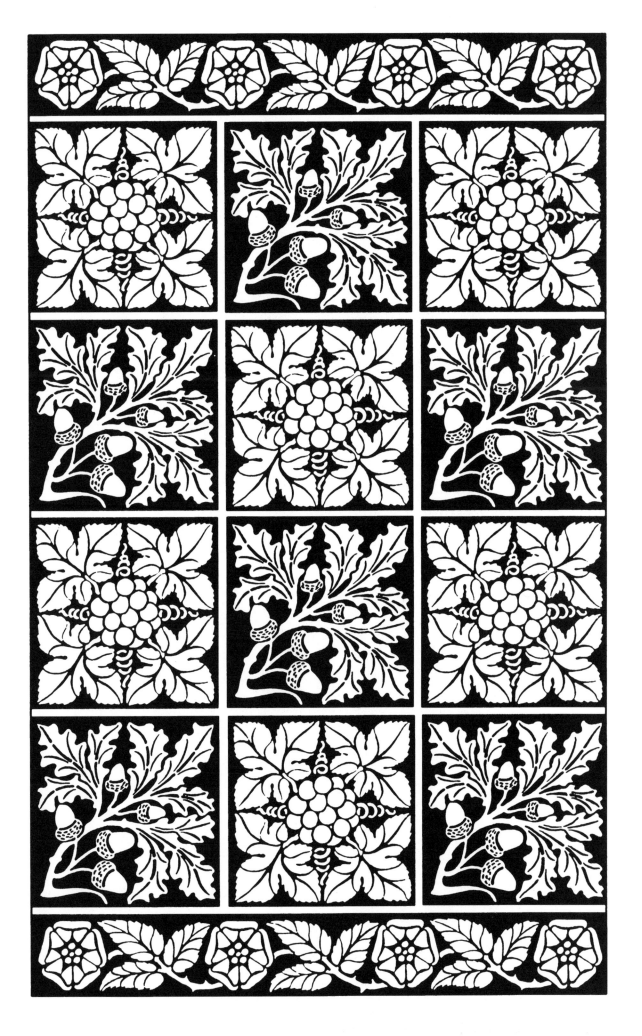

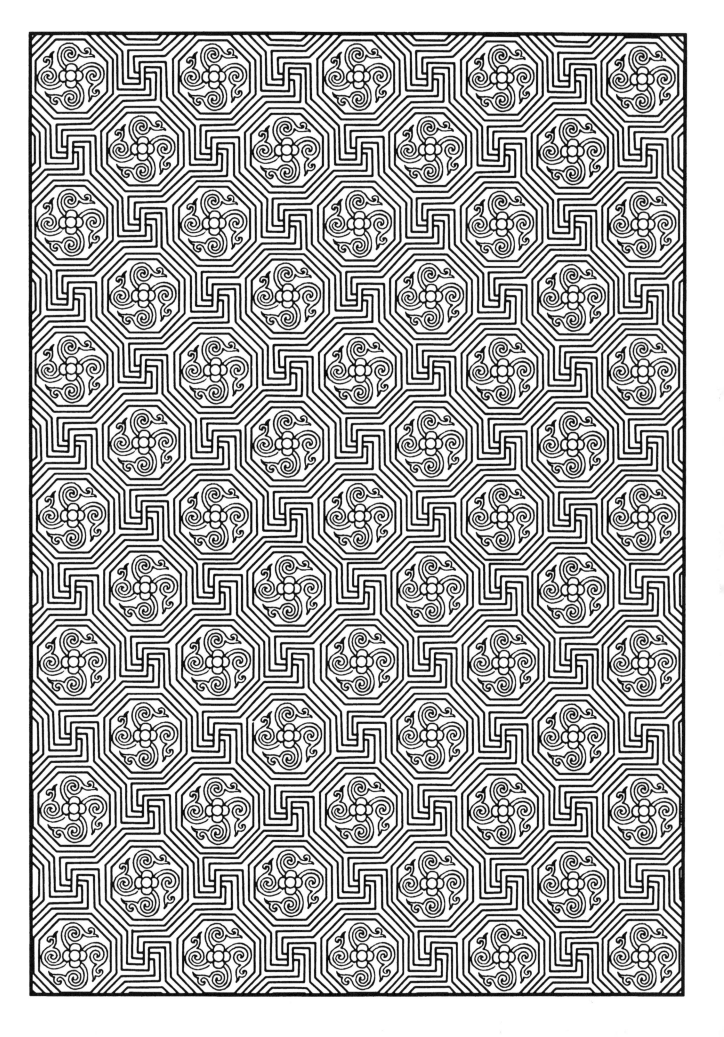

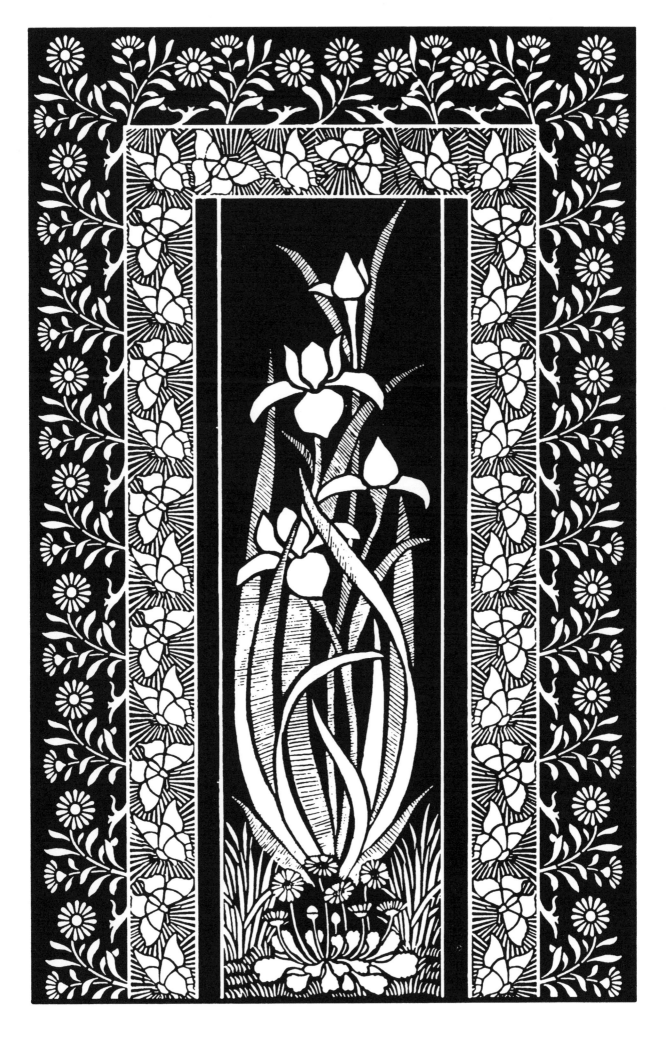

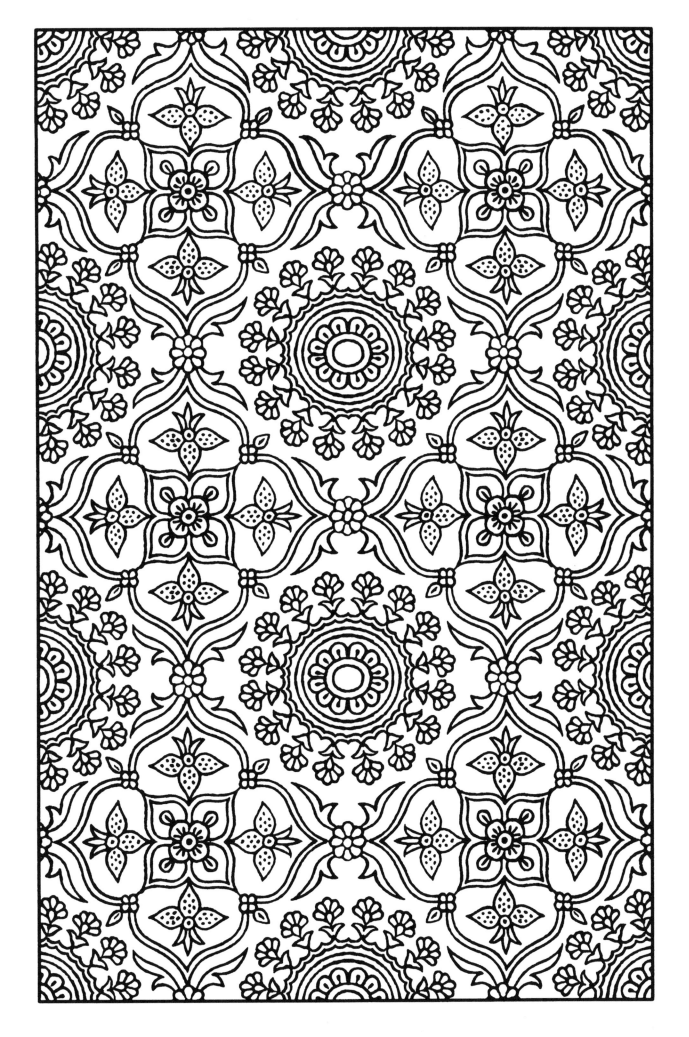

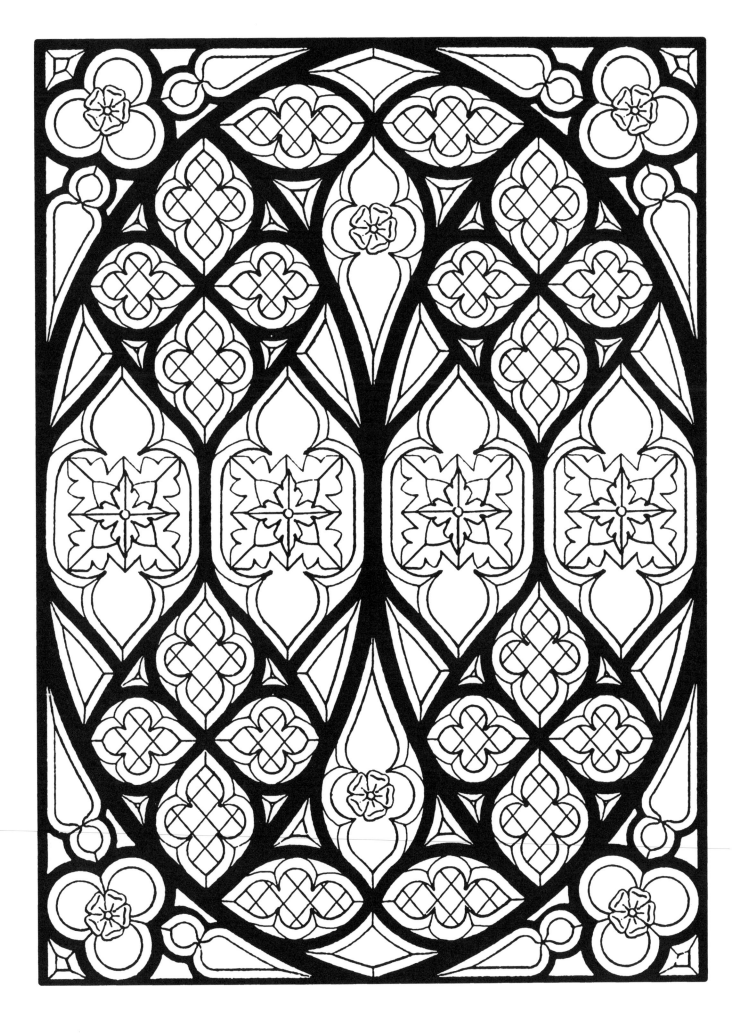

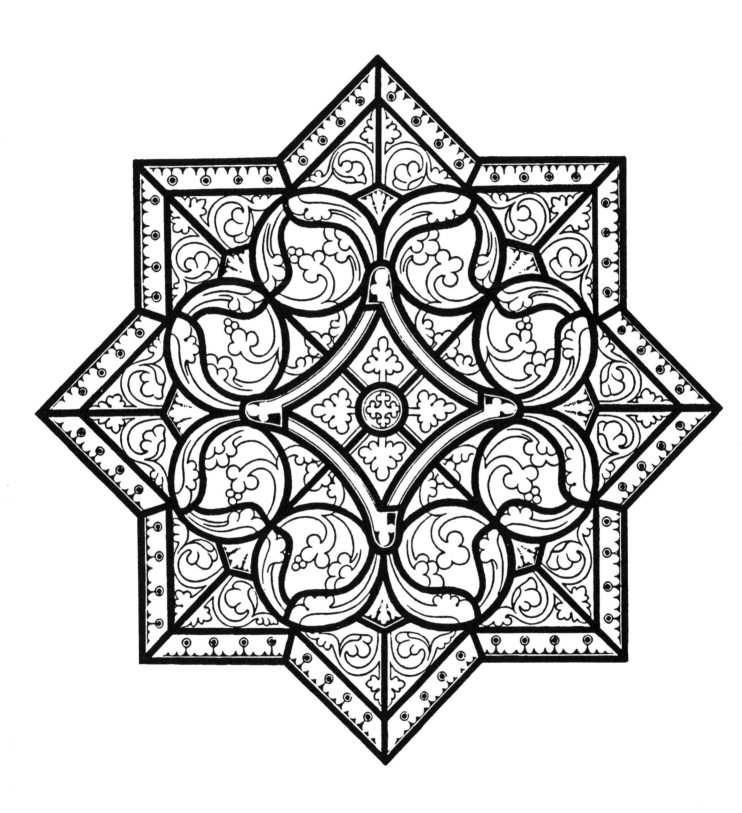

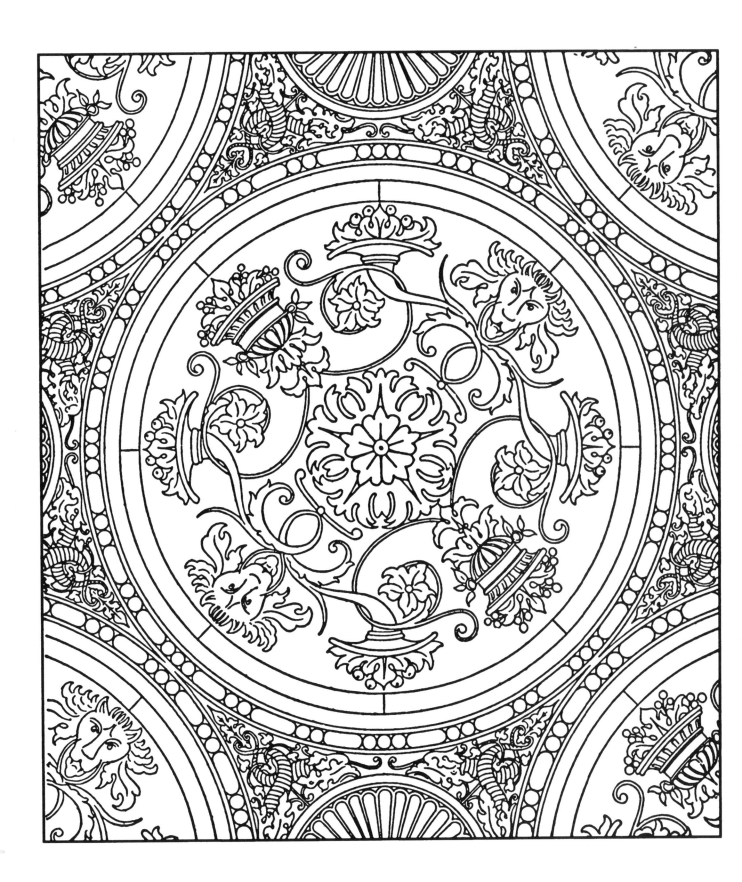

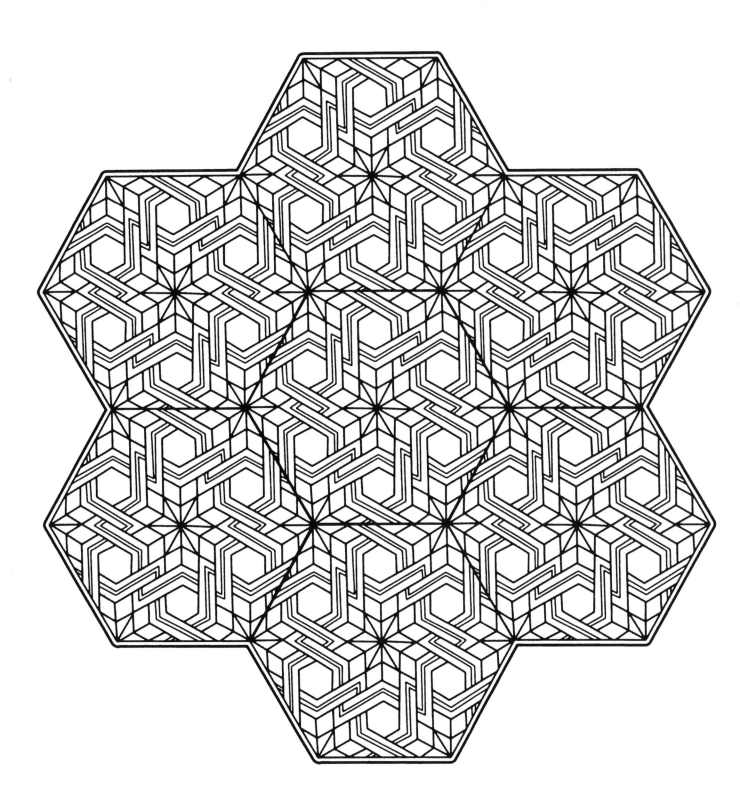

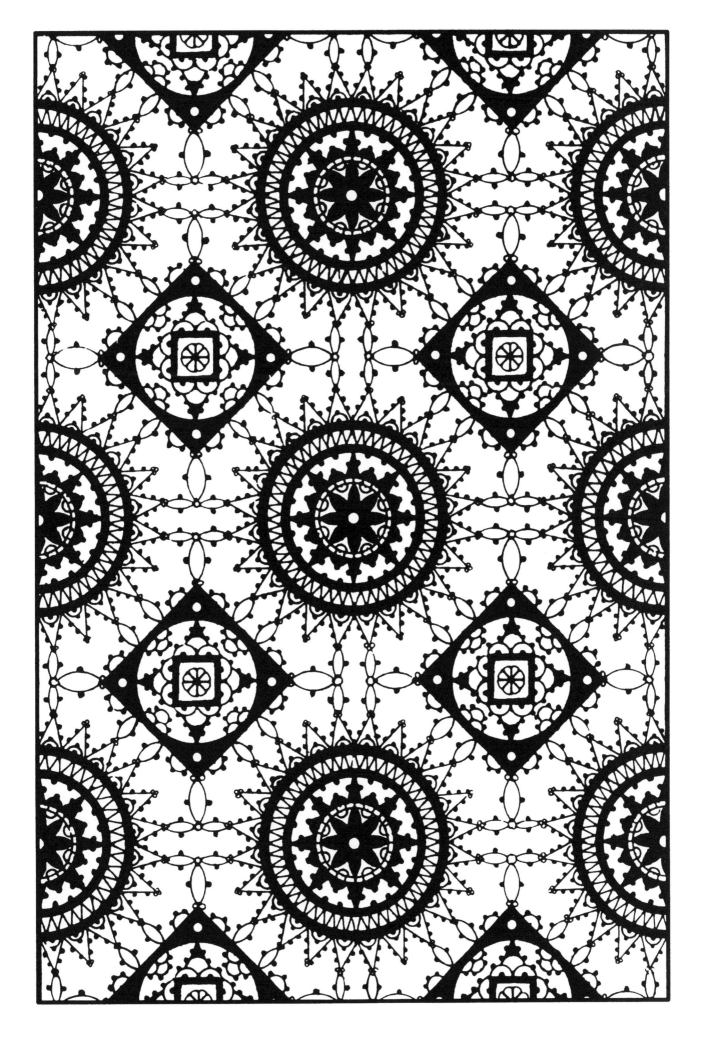

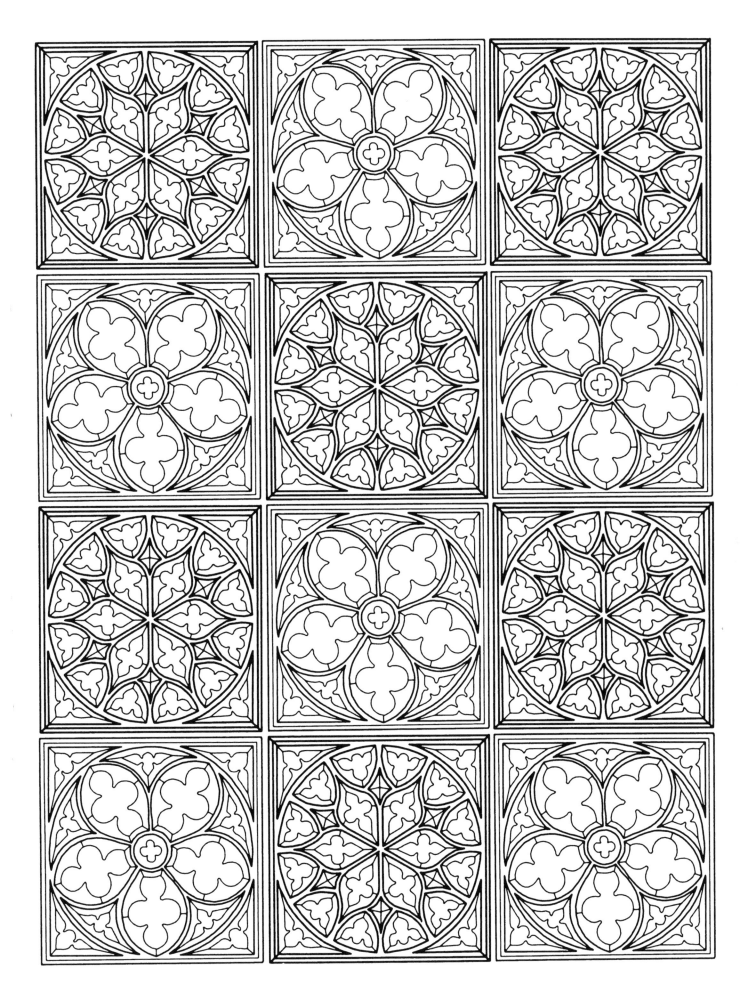

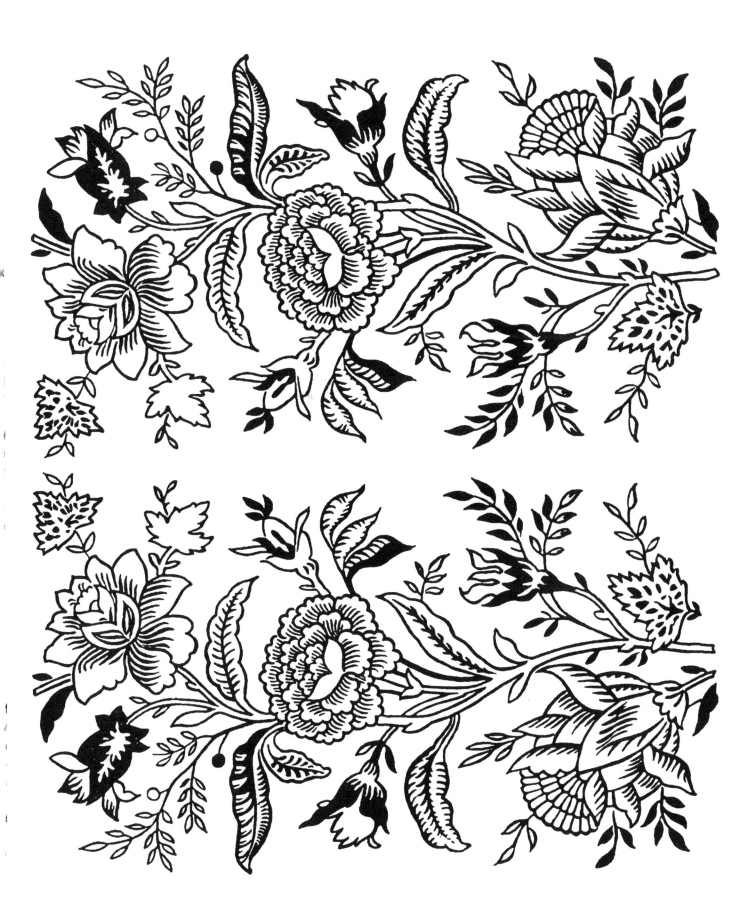

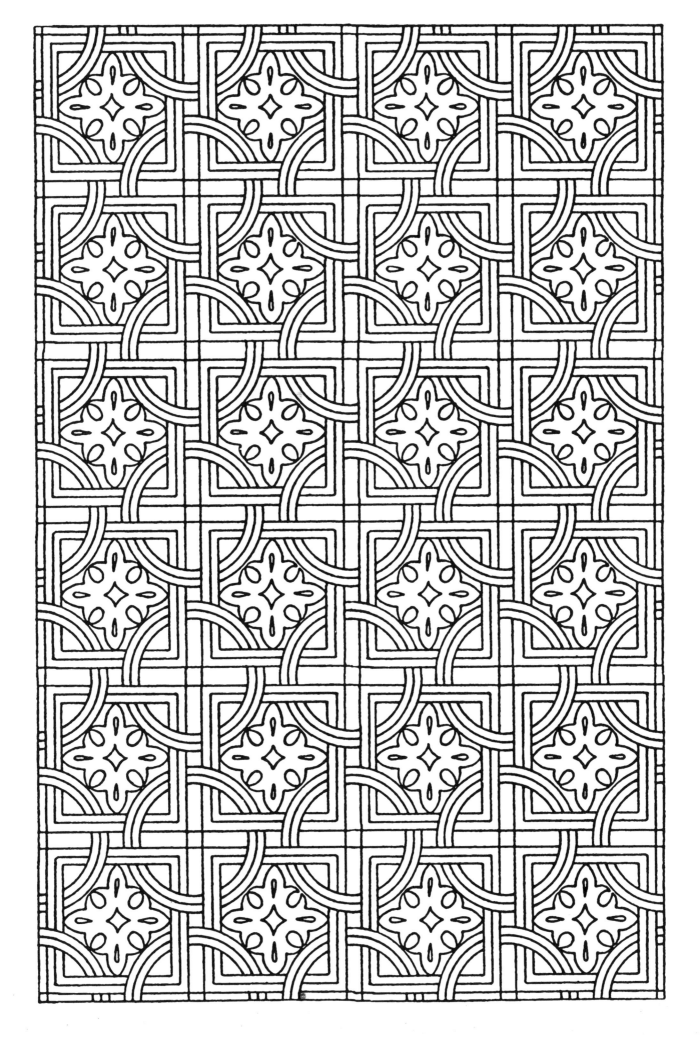

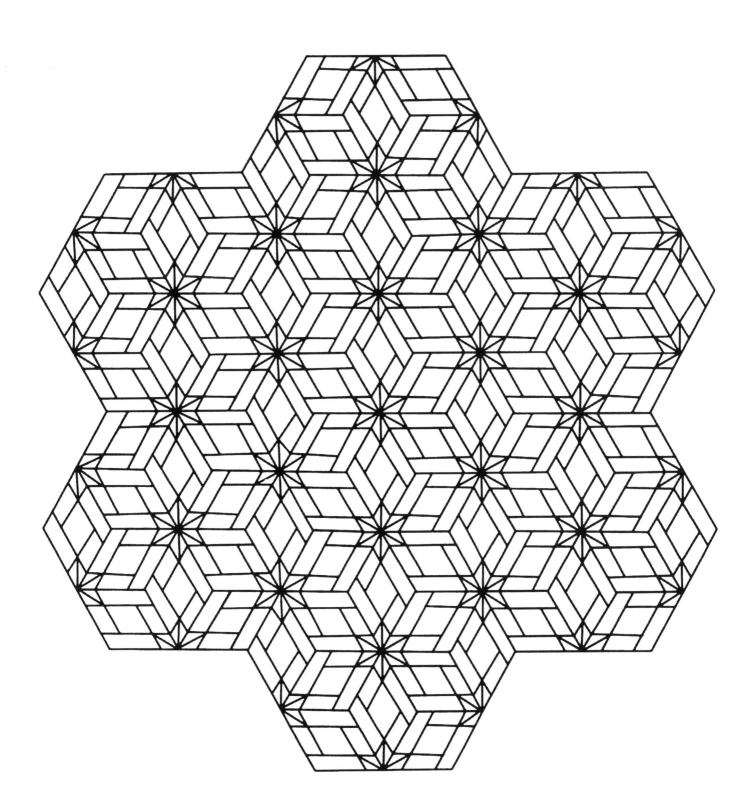

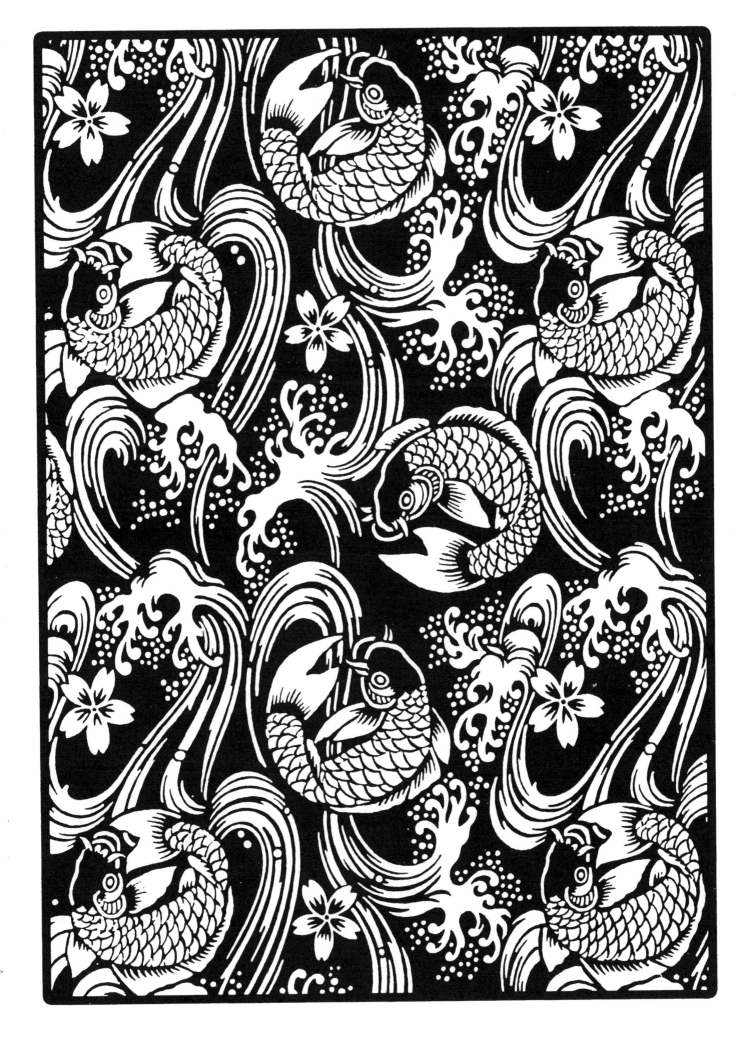

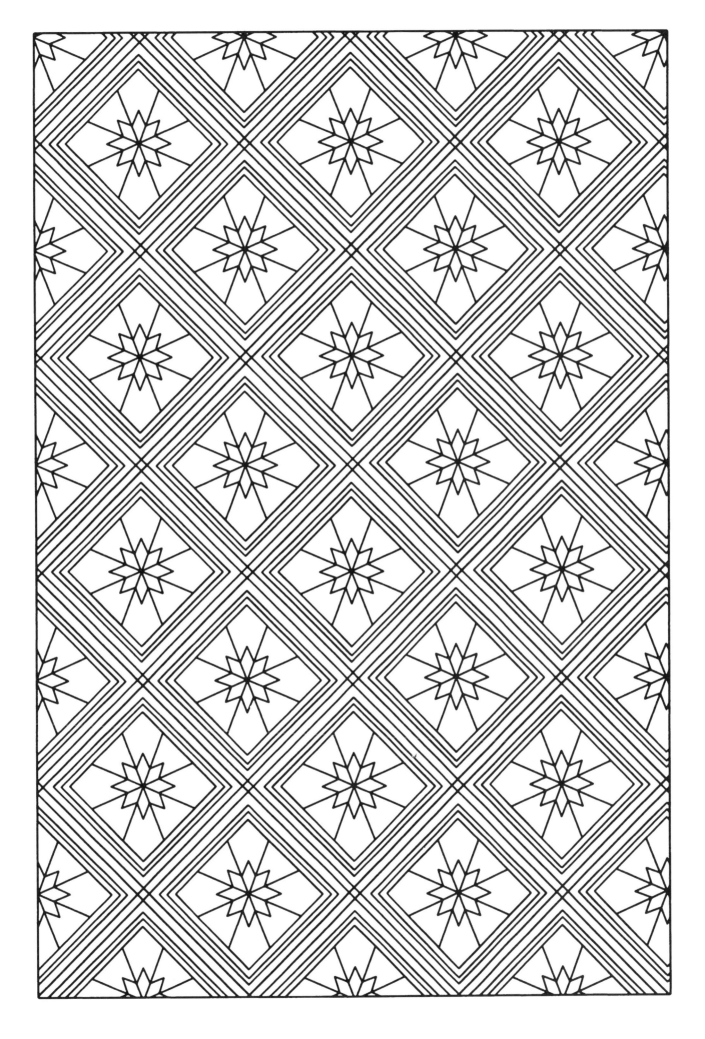

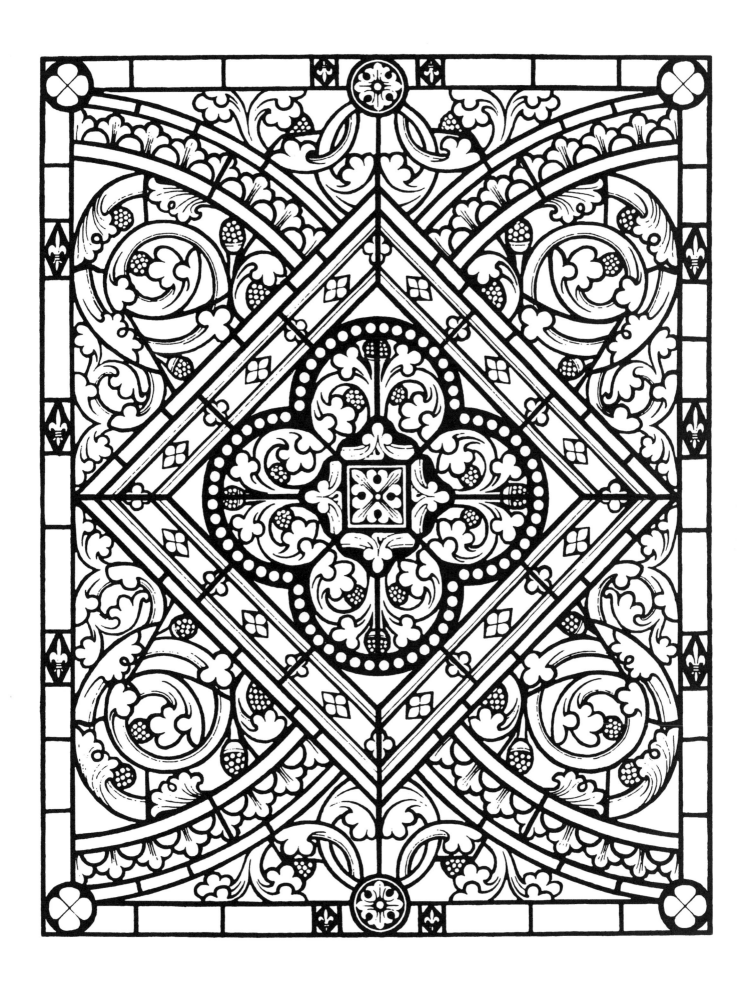

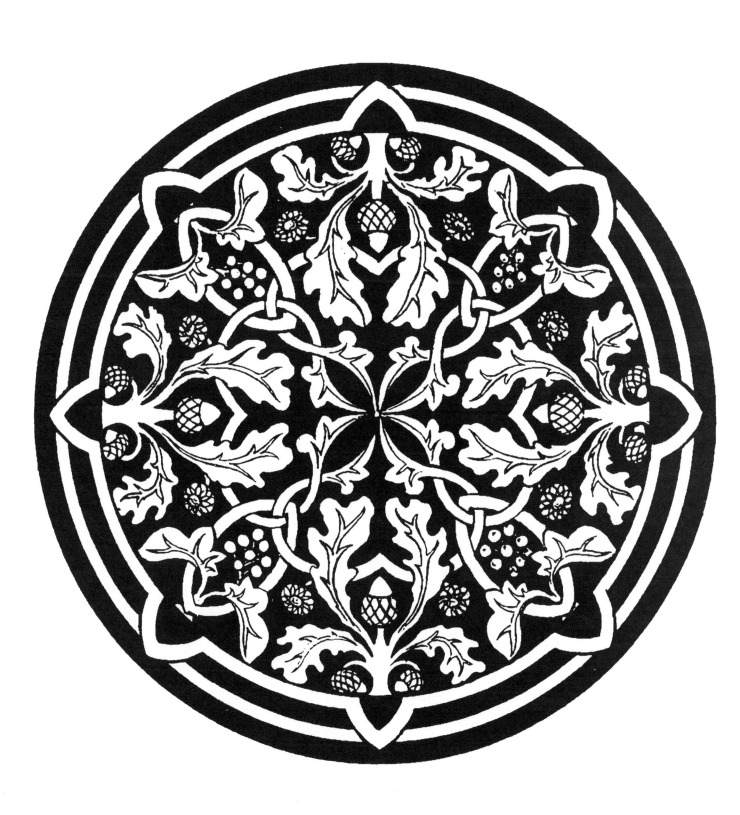

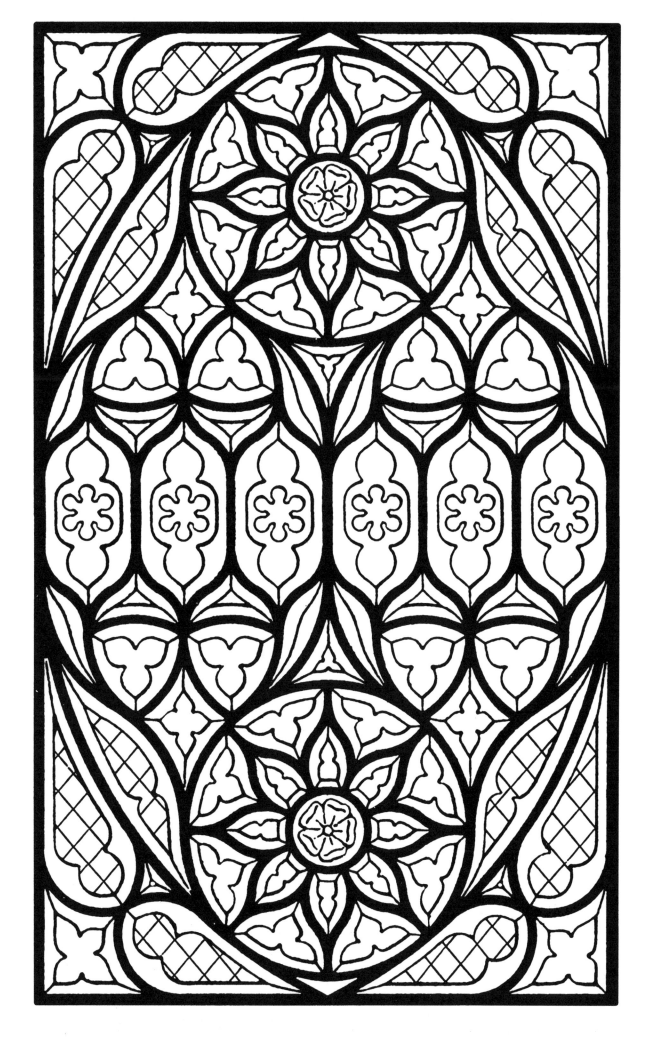

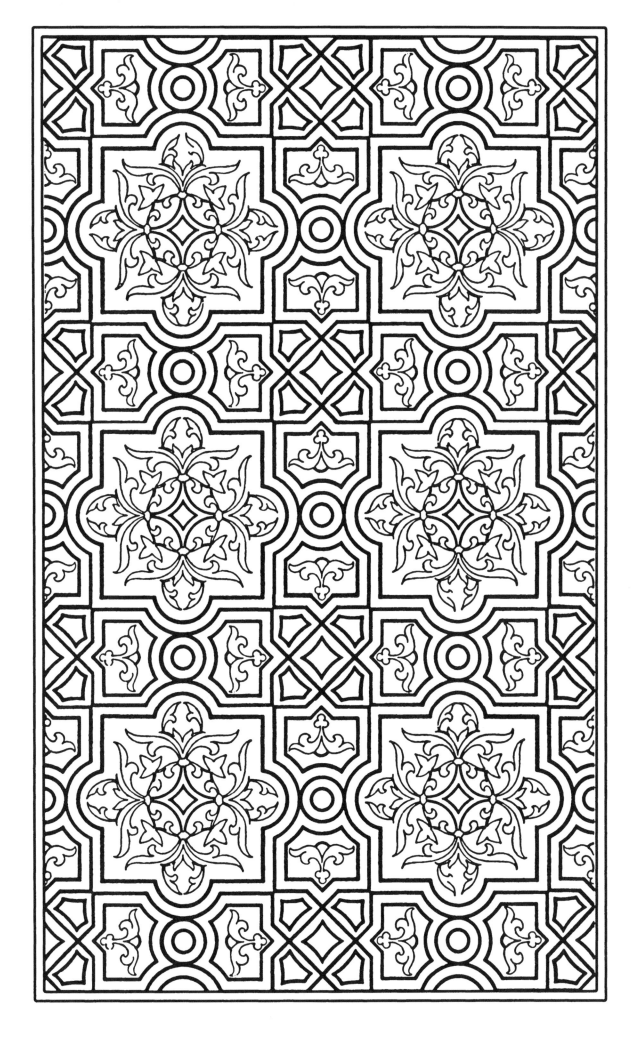

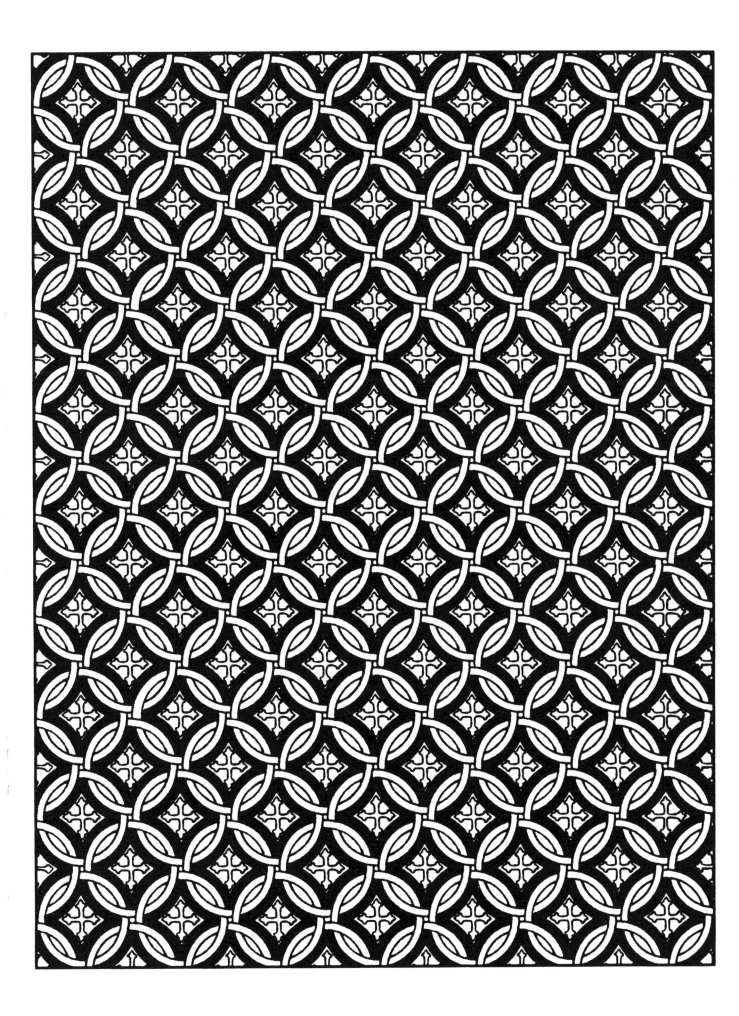

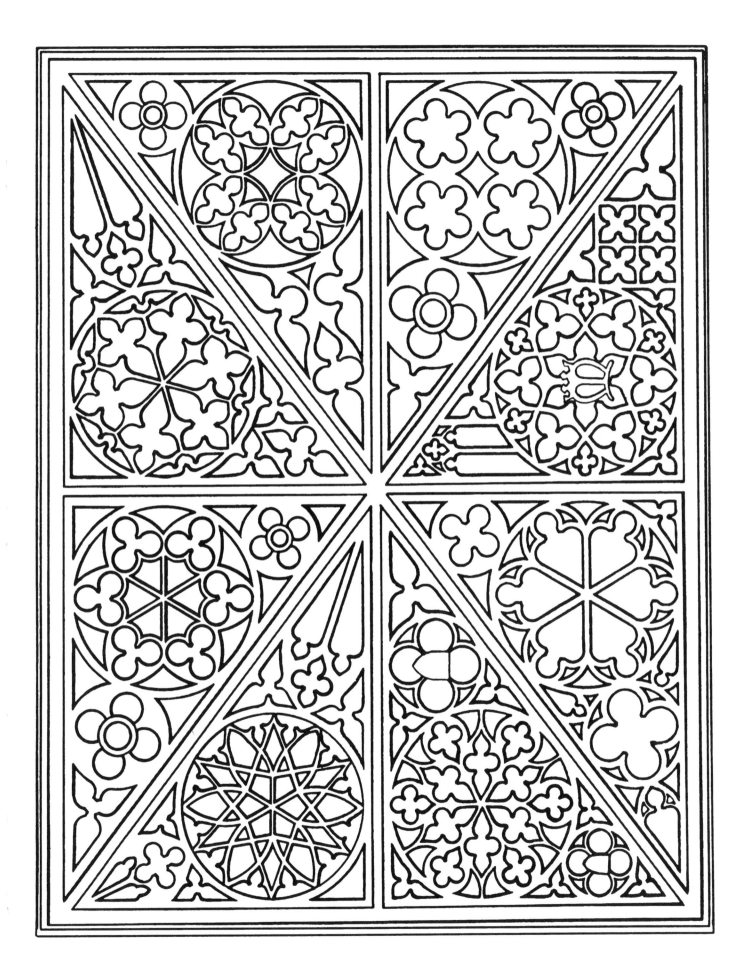

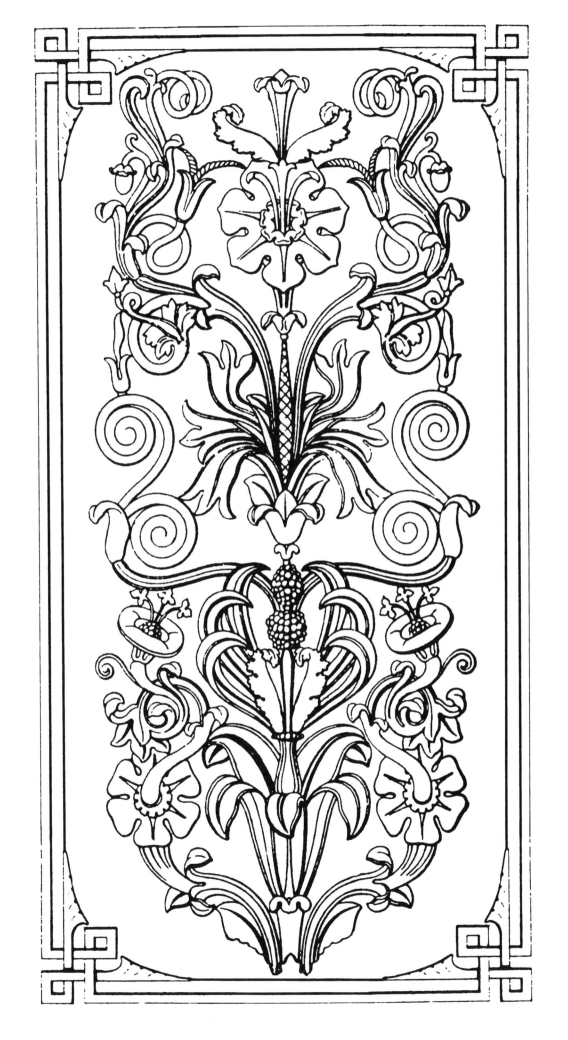

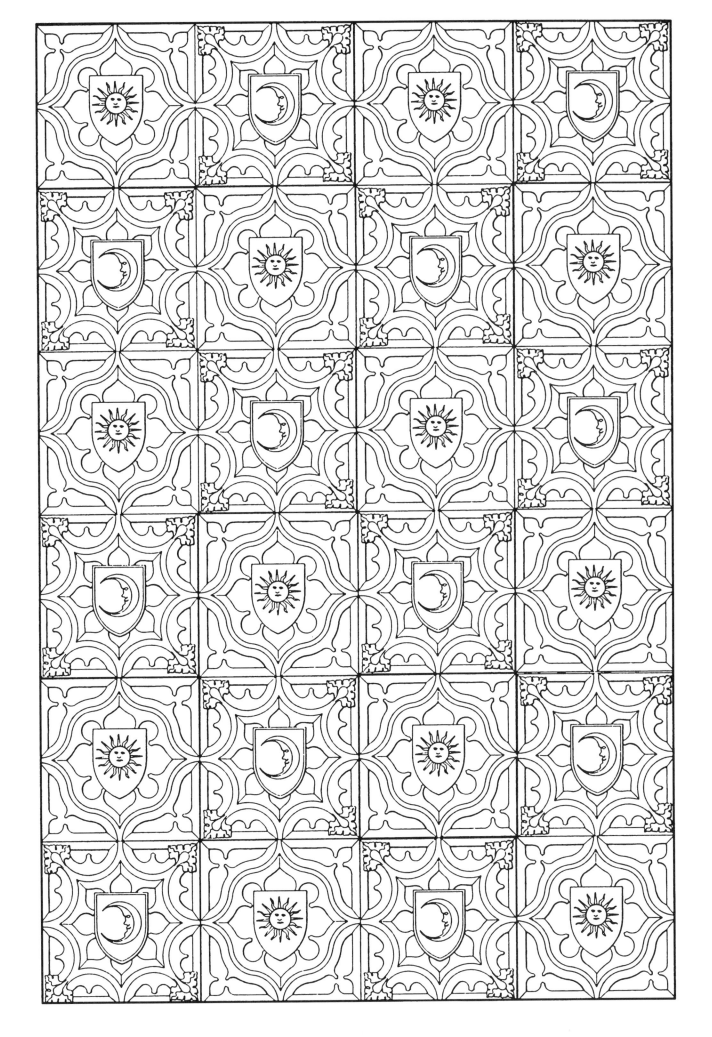

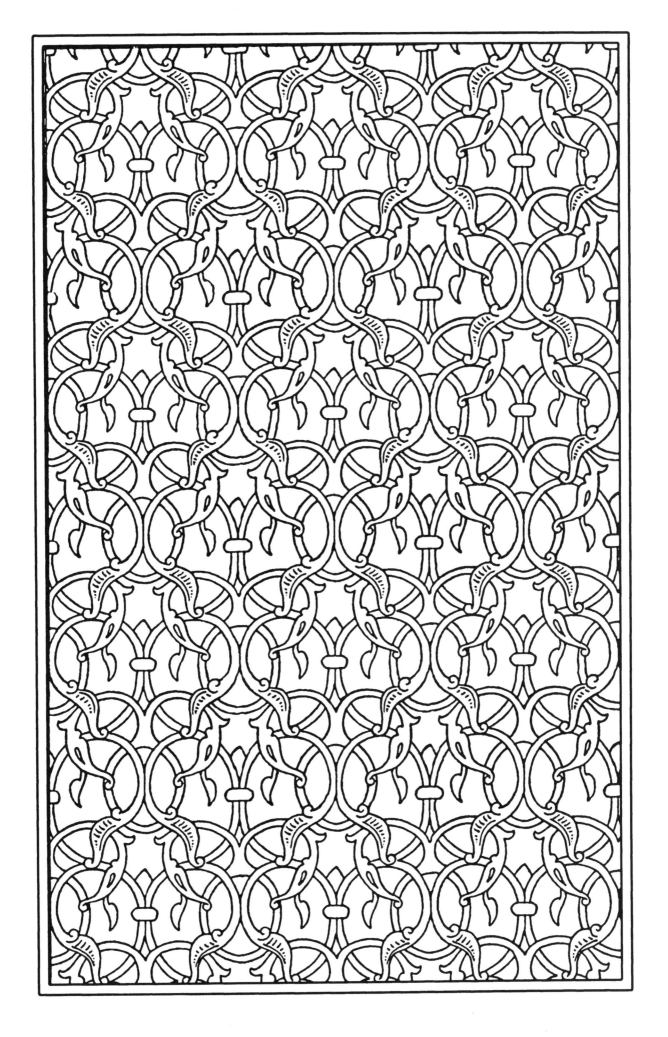

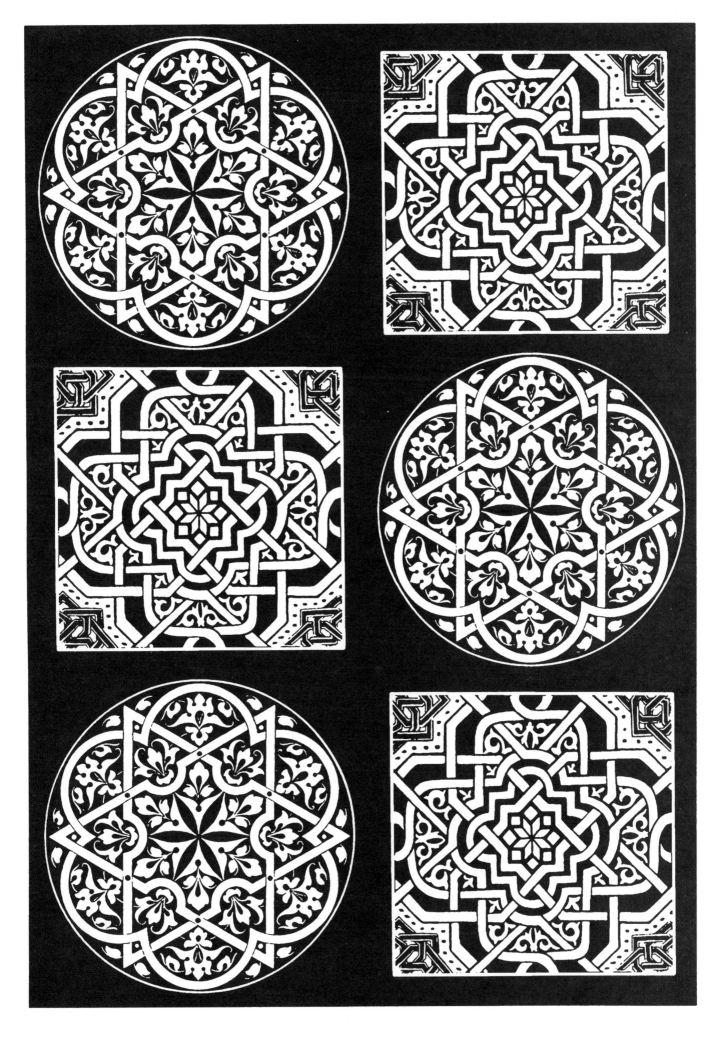

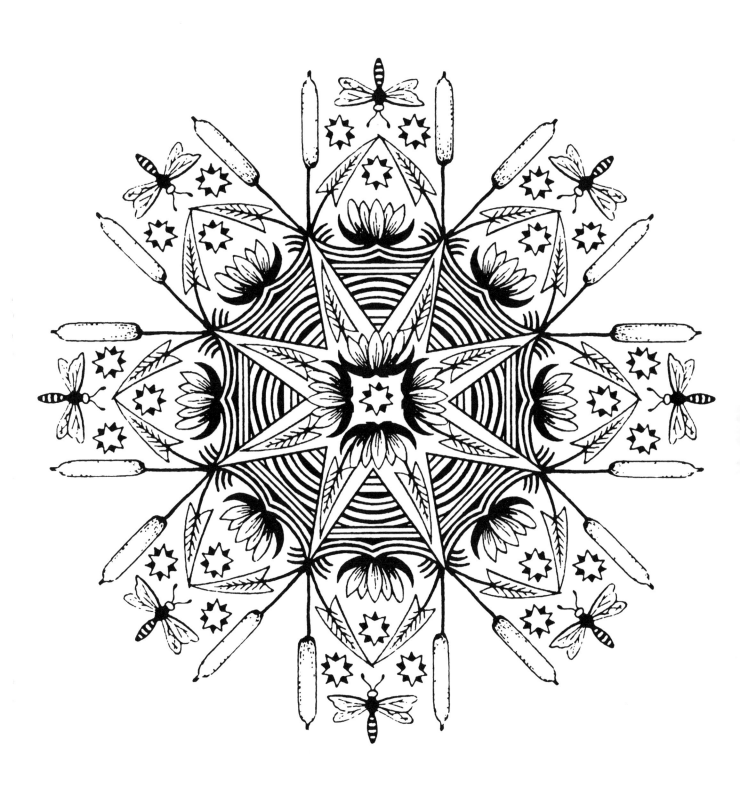